MID-CENTURY MODERN TILES

A History and Collector's Guide

Rob Higgins and Will Farmer

AMBERLEY

About the Authors

Rob Higgins has been collecting ceramics since the 1970s, with a particular interest in decorative tiles. He is a professor at the University of Warwick and has written books on *William De Morgan* and *Portmeirion Pottery*.

Will Farmer is a fine art and antiques auctioneer, specialising in ceramics, glass and twentieth-century decorative arts. He has appeared as an expert on the BBC *Antiques Roadshow* since 2006. His books include *Clarice Cliff* and *Poole Pottery*.

First published 2017

Amberley Publishing
The Hill, Stroud
Gloucestershire, GL5 4EP

www.amberley-books.com

Copyright © Rob Higgins and Will Farmer, 2017

The right of Rob Higgins and Will Farmer to be identified as the Author of this work has been asserted in accordance with the Copyrights, Designs and Patents Act 1988.

ISBN 978 1 4456 6566 5 (print)
ISBN 978 1 4456 6567 2 (ebook)

British Library Cataloguing in Publication Data.
A catalogue record for this book is available from the British Library.

Typesetting by Amberley Publishing.
Printed in the UK.

Contents

Acknowledgements

We would like to thank those who have helped us with their expertise and tile collections, especially Chris Blanchett. Lynn Pearson and the Tile & Architectural Ceramics Society have made it possible to visit architectural tiles around the UK through their *Gazetteer*. Peter and Pamela Higgins corrected many typos and grammatical errors.

Note on Illustrations

In the early 1950s most British tiles were listed as either 6 inches (152 mm) square or 4 inches (102mm) square. The actual size in production could be very slightly smaller to allow for the spacing between tiles when installed or because of shrinkage during drying and firing. Industry standards changed over time, so many tiles of the late 1950s onwards were 4.25 inches (108mm) square and, later in the century, 150 mm replaced 6 inches square. Unless otherwise stated, all tiles illustrated are 6 inches square; other sizes are given in metric or imperial units, according to the standard to which they were made.

Screen-printed Carter tiles on a table top, from the late 1950s.

Introduction

What is Mid-century Modern?

Mid-century Modern relates to design in the Modernist style from the 1930s to the 1960s. The term was coined in the 1980s, and initially applied to architecture and furniture but now covers other decorative objects.

Modernist style embraces literature, philosophy, art and design, and means any new construct not derivative of older or traditional styles. The origins of Modernism lie in the nineteenth century but it was in the early twentieth century that it impacted arts and literature. For example, the paintings of Picasso are a flagship of Modernism, particularly those in the Cubist style, which emerged in 1907–1908.

Modernism is distinct from other design traditions of the nineteenth and early twentieth centuries. Gothic Revival and the Arts and Crafts movement each had their roots in the medieval period. Art Nouveau emerged in the late nineteenth century and is transitional, but can be strongly Modernist.

Gibbons Hinton & Co. of Stourbridge made these Art Deco tiles in the 1920s.

Art Deco is Modernist and emerged at the Paris exhibition of 1925. Mid-century Modern replaced Art Deco in the 1940s and 1950s as shapes became more industrially inspired, and colours more pastel than primary. For example, the bright oranges and yellows of Art Deco, as seen so boldly in ceramics by Clarice Cliff, were replaced by softer yellows, blues and pinks.

Origins of Mid-century Modern Design

Architects played a pivotal role in developing Mid-century Modern, building on the earlier Modernist designs of Frank Lloyd Wright, Le Corbusier and the German Bauhaus. Concrete and steel were increasingly used to create structures in tune with the modern industrial age. Charles and Ray Eames in the United States were influential designers, especially well known for their lounge chair with its moulded plywood frame.

In European decorative arts, the architect and designer Gio Ponti was in the forefront of what was to become Mid-century Modern. His company was established in Milan in the 1930s and he also collaborated with the designer Piero Fornasetti. Clean lines, with careful use of colour and appropriate application of graphic detail, characterised their work. In Britain, Modernist ceramic design emerged during the 1930s when Wedgwood commissioned designs from Eric Ravilious and Keith Murray, though these were for tableware and vases and not for tiles.

British Tiles in the 1930s

Britain had a strong tradition of tile design and manufacture dating back to the eighteenth and nineteenth centuries. The production of decorative tiles peaked in the late nineteenth and early twentieth centuries, but they were still made in large numbers in the 1930s and, for example, were applied to the outside of many new cinemas of the period.

Watercolour from a factory pattern book, one of the 'Playbox' series by Alfred B. Read (1898–1973). Designed around 1930, it continued to be produced into the 1950s.

Carter & Co. of Poole, Dorset, was the leader in 1930s British decorative tile design. Nursery scenes were particularly popular. They also commissioned designs from notable artists of the day, such as Edward Bawden (1903–89). He graduated from the Royal College of Art in 1925, alongside the gifted Eric Ravilious, and was soon active in graphic design for companies such as Shell-Mex, Imperial Airways, and Fortnum & Mason. He designed a series of hand-painted tiles in the 'Sporting' series for Carter & Co.

Another notable artist who could be seen as bridging Art Deco and Mid-century Modern design in the 1930s was Polly Brace. She studied at the Central School of Art in London in the 1920s and, together with Kathleen Spilsbury, established Dunsmore Tiles in around 1925. Blank tiles were decorated using stencils to apply the main design with fish, animals and signs of the Zodiac being popular.

S.P. 2.

Edward Bawden was a celebrated artist and graphic designer. In around 1930, he designed a series of tiles called 'Sporting' for Carter & Co. of Poole. This is a watercolour from a Carter & Co. pattern book.

Dunsmore Tiles was established by Polly Brace and Kathleen Spilsbury around 1925. Their innovative designs were produced using a stencilling technique. This example is from the 1930s.

Mid-century Modern in Britain

Rebuilding the nation's infrastructure after the Second World War was a priority, and both architects and public bodies promoted Modernism. The buildings of F. R. S. Yorke were especially significant because of his use of decorative tiles in many public commissions during the early 1950s.

International recognition of British Mid-century Modern design was achieved during the 1950s through the work of artists such as Graham Sutherland, the sculptors

Henry Moore and Barbara Hepworth, and fabric designers including Lucienne Day and Robert Stewart. Their sculptural and graphic styles were very influential across all areas of contemporary design, including decorative tiles.

Screen printing was adopted by many manufacturers in the early 1950s and was ideally suited to the fields of colour used in many Modernist designs. It could also be semi-automated to allow large-scale production. Other techniques, such as wax-resist and reactive glazes, became popular in the 1960s and 1970s, adding a new dimension to tile design. These techniques supplanted hand painting, transfer

Silver lustre lion on a Richards Tile Co. blank, dated April 1945 and decorated at Gray's Pottery in Stoke-on-Trent, probably adapting a design by Gordon Forsyth. He worked for Gray's Pottery in the 1920s while Superintendent of Art Instruction in Stoke-on-Trent, after his spells with Minton Hollins & Co. and with Pilkington's Tile & Pottery Co.

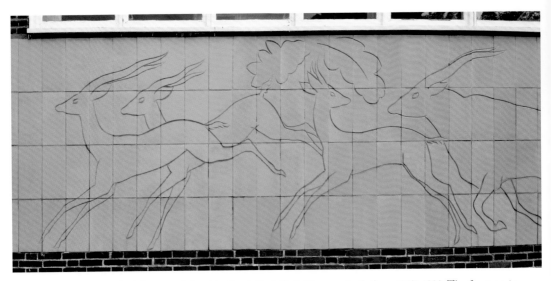

The Three Lane Ends Primary School in Castleford, Yorkshire, was built from 1937–1939. The frontage is dominated by life-sized leaping animals incised into jade-green Carter & Co. tiles designed by the artist John Skeaping (1901–80), who was the first husband of the sculptor Barbara Hepworth.

Pair of 4-inch tiles by Carter & Co., showing contrasting use of slightly different colours printed through the same screens.

printing and block printing, which were the most prevalent techniques for tile decoration before the 1950s.

Although a large tile mural could be used by an architect as the focal point of a large architectural project, most tiles within a domestic setting were regarded as accents, complementing other design features. This required a particular design skill, as a tile fireplace or tiled coffee table had to sit alongside bold new fabrics or wallpaper. Despite these constraints, British tile makers developed a Modernist style that was not simply

Advertisement for 1950s curtain materials by David Whitehead & Sons Ltd of Lancashire.

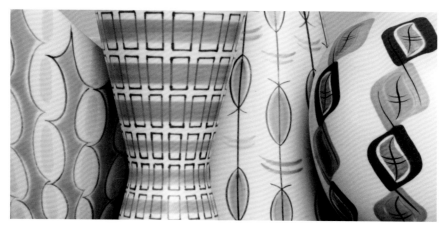

In the 1950s, Poole Pottery produced a wide range of Modernist designs but, as curved surfaces were not suitable for screen printing, these were hand painted. Poole Pottery was a 1920s offshoot of Carter & Co. tile manufacturers, though the companies retained close links.

derivative of overseas or even other British design, but that also embraced and exploited the new technologies to create powerful products that have stood the test of time.

For the twenty-first-century collector, Mid-century Modern tiles represent an interesting opportunity. Single tiles by major designers are available for a couple of pounds, though more desirable tiles or tables may achieve much higher prices. Tiles are fairly easy to display, owing to their size, and it is easy to change a display at regular intervals if a collection expands. This book will illustrate the pivotal designs that make up the catalogue of British Mid-century Modern tiles.

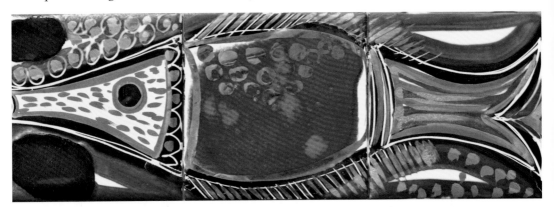

A small panel by Rhys and Jean Powell, late 1960s.

Rebuilding Britain and Austerity

Detail of mural at St Aidan's Church, Leicester.

After the Second World War, the national priorities were to rebuild the nation and to export manufactured goods. Decorative building materials in the home market carried prohibitive purchase taxes until 1952. The ceramics industry had escaped nationalisation, if only because the government could not afford to nationalise more than core industries such as transport, energy and steel. The government did, however, establish the Council of Industrial Design (COID), which promoted Modernist design to all private manufacturers.

The COID held the 'Britain Can Make It' exhibition in 1946 at the Victoria and Albert Museum. It was soon dubbed 'Britain Can't Have It', as the emphasis was on goods for export. Carter & Co. took a stand and presented new tiles by Susan Williams-Ellis (1918–2007). She studied at the Chelsea Polytechnic before the War, where one of her teachers was Graham Sutherland. Her tile series was called *Sea* and was inspired by the Welsh coastline at Portmeirion, the holiday village built by her father. Seaweed, shells and crustaceons were outlined in soft pinks, yellows and greens. Although Susan Williams-Ellis returned to the Welsh coastline for inspiration later in

The first new design series from Carter & Co. after the Second World War was 'Sea', by Susan Williams-Ellis, which was exhibited at 'Britain Can Make It' in 1946. Here is a single tile from that series.

her career, this proved to be her only series of tile designs. Just over a decade later, she established the Portmeirion Pottery in Stoke-on-Trent and became the pre-eminent British tableware designer throughout the 1960s and 1970s.

Screen Printing

Covering an area of a tile with an even application of colour was not easy. Hand painting, stencilling, painting or printing with a rubber block did not always give an even coating, and nor were the edges of the design perfectly clean. In screen printing the coloured glaze or enamel was pushed through a mesh screen, part of which was coated so that it was impermeable, allowing a more even and rapid application of colour. A photographic technique was developed to transfer a design from paper to screen, and this was cheaper than making the metal blocks required to print lithographic transfers.

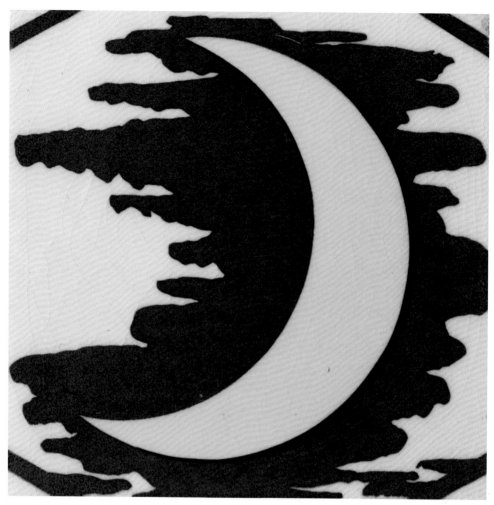

Above: Moon, possibly designed by Peggy Angus, on a tile dated 1951. This is an early use of screen printing by Carter & Co.

Below: Three Carter & Co. tiles from the 1950s. In the centre is a 'Circle' design by Peggy Angus. Together with other simple geometric forms, 'Circle' was used to great effect in the Susan Lawrence School in Poplar, London, which was featured as part of the Festival of Britain in 1951.

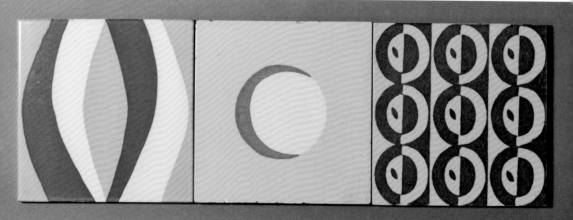

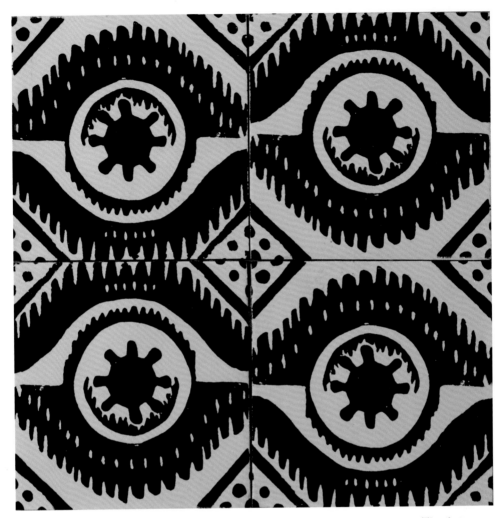

A Peggy Angus design, adapted from one of her lino cuts and produced by screen printing. This design was used in the interior of some schools built in the early 1950s.

Screen printing was developed for tile production in the early post-War period at Carter & Co. and was promoted especially by one of their senior designers, Reginald Till (1895–1978). He had studied at the Schools of Art, Science and Technology in Stoke-on-Trent and then at the Royal College of Art in London, before joining Carter & Co. in 1923.

A production line was built at the Poole factory to semi-automate screen printing. This led to a huge number of designs from Carter & Co. during the 1950s, employing relatively simple geometric patterns, often with a *tromp l'oeil* effect. The colour palette was pale green, pink, grey and yellow, exactly in tune with 1950s interior design. Reginald Till worked for Carter & Co. until 1951, when he left to establish the Purbeck Tile Company with John Bowman, a former Carter's director.

Other companies, such as H & G Thynne in Hereford and a number of Staffordshire potteries, also produced tiles using similar geometric effects. Reginald Till at Purbeck

Screen printing usually set colours side by side, but this Reginald Till design, made by Purbeck Tiles in 1964, shows several layers skilfully built up.

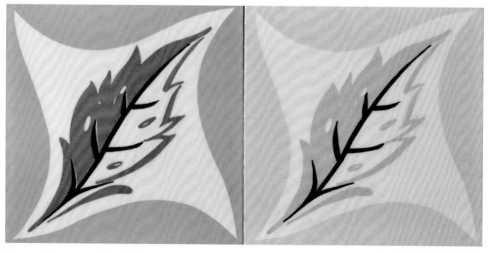

A pair of tiles inspired by the Festival of Britain and intended for domestic use, made by Thynne & Co. in 1955.

tiles produced some complex and beautiful screen printing, layering colours over each other rather than simply putting them side by side.

Screen printing was welcomed with enthusiasm by a number of architects, who used panels of geometric designs inside or outside buildings. In *Design* magazine, the mouthpiece of the COID, the use of tiles was endorsed thus:

> The tile is essentially a flat slab, usually square, which is applied in repetition to make a tiled surface ... This repetitive application is both tiling's limitation and its great asset as a decorative medium, for it allows the user to compose his own patterns, instead of having to choose them ready made, as he does in textiles, wallpapers or carpets. This is the way to get the best out of tiles – to use them as standard units to build up special patterns to suit a particular job.

Peggy Angus

One of the most important designers in the immediate post-War period was Peggy Angus (1904–93). She was born in Chile, where her father worked on the railways before the family came back to north London. One of thirteen children, she won a scholarship at the Royal School of Art in London, but still had to work on the family sewing machine at night after her studies. Her contemporaries and teachers at art school in the 1920s included Eric Ravilious, Edward Bawden, Reginald Till and

A group of Carter & Co. pattern making tiles, designed by Peggy Angus, on an exterior wall in Leeds city centre. Compare with the blue tiles behind Lady Godiva in Coventry on the facing page.

Paul Nash. She then worked as a secondary-school art teacher and was also part of a circle of artistic friends and socialists, who often met at her spartan country cottage in Sussex, Furlongs.

Through Carter & Co. she developed a close collaboration with the architect F. R. S. Yorke. He had been commissioned to design new schools after the Second World War and these projects fitted closely with her ideals for 'social architecture'; this was the creation of a humane environment for the education of the young as opposed to Victorian buildings, which were often perceived as dull and gloomy. She also designed a large tile mural for the Brussels Universal and International Exhibition in 1958. As the use of tiles in large architectural projects declined by the end of the 1950s, more of her designs were sold for domestic use. Peggy Angus continued as a consultant designer for Carter & Co. until the early 1960s.

Festival of Britain

One of Peggy Angus's first projects with F. R. S. Yorke was the Susan Lawrence School in Poplar, London. This was selected to be a 'Live Architecture' project as part of the 1951 Festival of Britain and featured on the front cover of the *Architectural Review* magazine as the festival opened. The Festival of Britain itself, centred on the South Bank of the River Thames in London, had as its principal aim 'to bring to the British way of life some enrichment that will endure long after the Festival year is over'. The main festival site on the South Bank had exhibitions that covered a series of themes such as

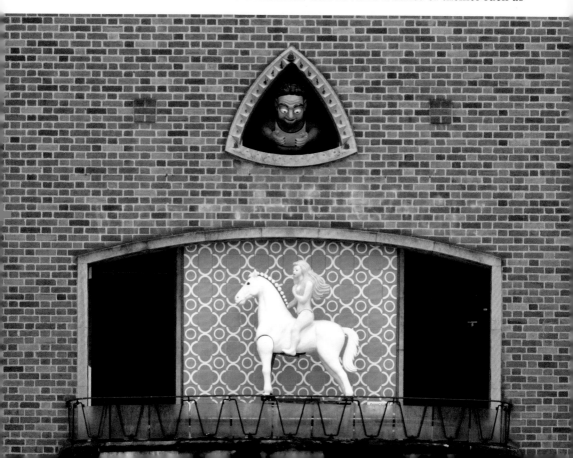

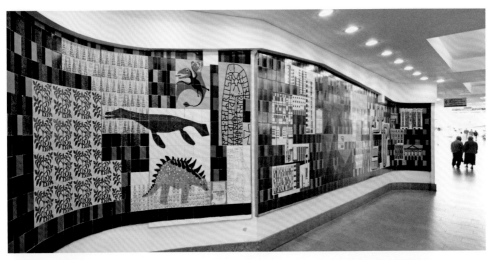

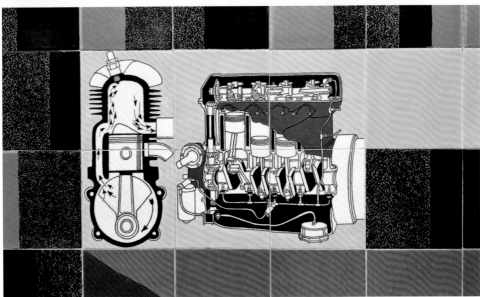

After the 1940 Blitz, the centre of Coventry was redeveloped. In the Upper Precinct, 1948–1952, is a Godiva and Peeping Tom clock with a backing of Carter & Co. tiles designed by Peggy Angus (see page 19). In the Lower Precinct is a mural designed by Gordon Cullen (1914–94) in 1957 and executed by Carter & Co. This portrays the history of Coventry from the Carboniferous to the present (above). The detail below shows a two-stroke motorcycle engine and a Coventry Climax racing engine.

'The Land of Britain', 'Power' and 'Production and Transport'. Austerity restrictions were still in place, so the public could not buy the decorative ceramics on show. Tiles did feature among over 100 murals on the festival site, though many of these used other materials such as metal and concrete. Reginald Till designed a large tile panel with an atomic structure based on the chemical composition of zinc hydroxide, and this was part of a project by the Festival Pattern Group to bridge the gap between art and science. Atomic designs inspired by the festival continued to be popular on tiles for some years. Most of the festival site was cleared during the 1950s, together with the

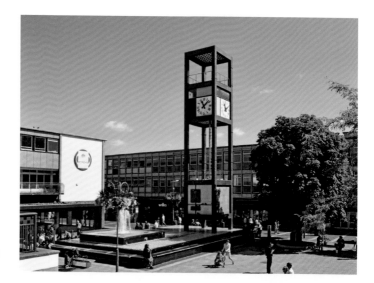

Stevenage New Town shopping precinct was built in 1957–9.

The Clock Tower is decorated with a stylised map of the town designed by Leonard Vincent; the tiles were made by Carter & Co.

Upper stories of the clock tower are clad with Carter & Co. pattern making tiles designed by Peggy Angus.

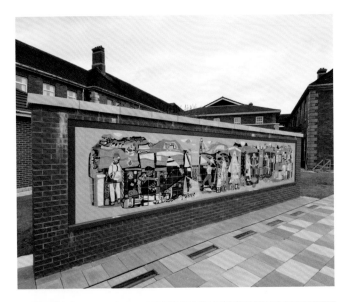

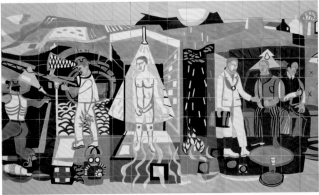

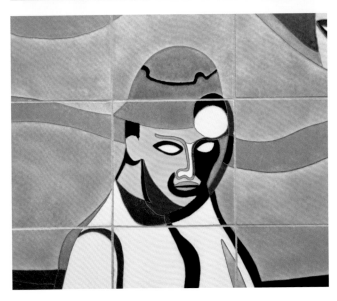

The National Union of
Mineworkers commissioned this
large tile panel for the research
institute at Llandough Hospital
in the late 1950s. It was designed
by local artist Michael Edmonds
and made by Carter & Co.
It shows scientists monitoring
underground conditions and
follows the miners into the lung
clinic and research laboratories.

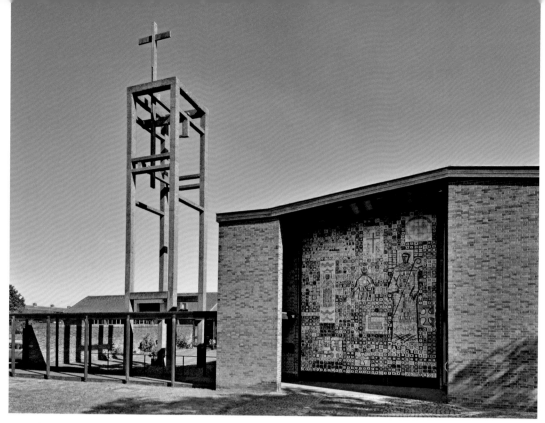

A number of new Roman Catholic churches were built after the Second World War. Notable is St Aidan's on New Parks Boulevard in Leicester, designed by architect Basil Spence & Partners, and built 1957–9. The west wall is covered with a tile mural designed and decorated by the Loughborough artist William Gordon, depicting the life of St Aidan.

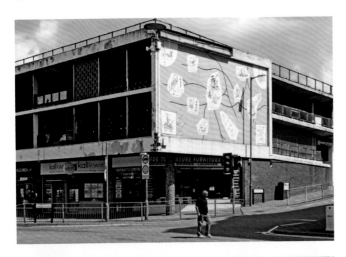

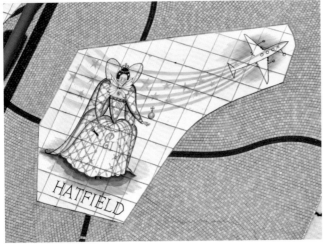

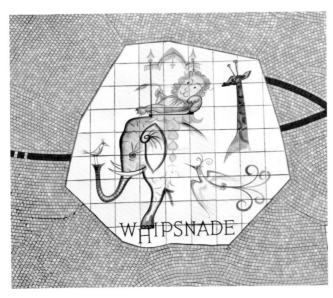

Hemel Hempstead was one of several 'New Towns' developed after the Second World War. A tile mural remains on the side of a multi-storey car park, constructed in 1960. Rowland Emett, a cartoonist and maker of whimsical kinetic objects, designed the images, which were painted by Phyllis Butler of Carter & Co. The tile panels are set in grey mosaic and show local towns and attractions linked to Hemel Hempstead.

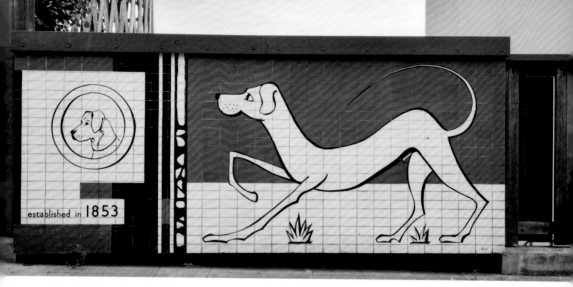

Dane Printing of east London adopted a Great Dane dog as their logo. Carter & Co. installed this attractive panel outside their works on Stratford High Street.

Queen Mary College in London commissioned tile murals from Carter & Co. for the new Engineering Building (1958) and Physics Building (1960/1). This is one of a series of panels outside the Physics Building.

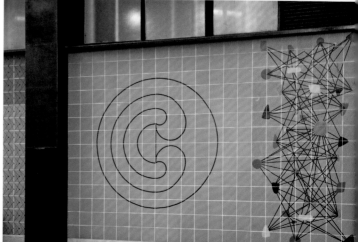

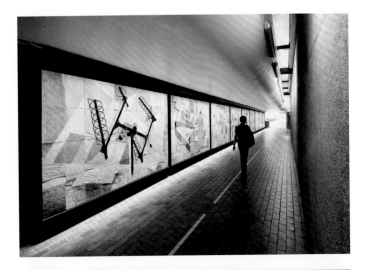

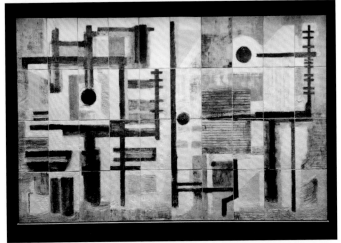

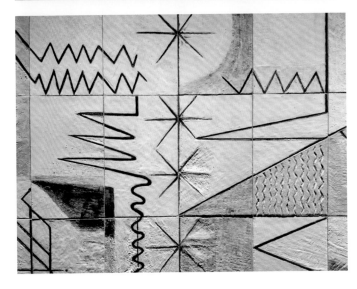

The General Post Office commissioned the artist Dorothy Annan (1900–83) to design and make a series of murals for their building on Fleet Street, London. The nine tile panels each illustrate a different facet of telecommunications. The original building has been demolished and the panels have been relocated to the nearby Barbican Centre.

artwork. The Victoria and Albert Museum has images of the Till tile panel, as well as his personal archive.

The Festival of Britain and associated architectural projects established the popularity of tile murals on public buildings for the rest of the 1950s, until concrete Brutalism banished almost all decorative tile murals. Tiles were still used, but usually as plain or slightly textured products to cover large areas of internal or external walls. Carter & Co. dominated the market for tile murals in the 1950s and many of these are still visible in city centres such as Coventry, Sunderland, Leicester, Belfast and London; however, this is not to say that the use of ceramic tiles was universal. While the revolutionary 1958 shopping precinct in Coventry has a large Carter & Co. tile mural, Coventry Cathedral – the masterpiece of Mid-century Modern in Britain – has no decorative ceramic wall tiles.

Towards the End of Austerity

During austerity there was a huge pent-up demand for decorative objects to use and display around the home. One company in particular found a hugely successful way around the restrictions. Sylvia Packard and Rosalind Ord established Packard & Ord in 1929, combining their skills as designers and painters to make a range of tiles with figurative designs including flowers, birds, and scenes in the Dutch tradition. Some designs had a strong Art Deco feel, but their catalogue was not Modernist. After the war, they exploited the fact that decorative tiles in wooden frames for household use were classified as furniture and so were not subject to punishing taxation in the home market, making them incredibly popular. It is estimated that in 1951 alone they produced 12,000 tea trays, many of which survive today and are readily available to collectors. Their brand of traditional and sometimes modern design continued to be successful, and the company is trading in the twenty-first century as Marlborough Tiles.

In August 1952 the Austerity restrictions on decorated tiles came to an end. The release of a repressed demand for the home, together with a new generation willing to embrace Modernism, led to the production of a large range of decorated tiles over the rest of the decade.

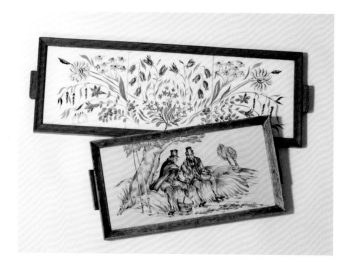

Packard & Ord incorporated tiles into trays and furniture, circumventing the austerity taxes and restrictions on decorative ceramics.

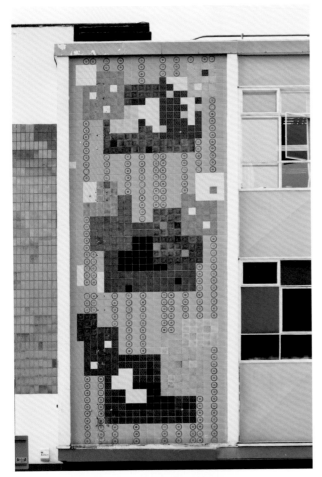

The most prominent Mid-century Modern tile mural in Stoke-on-Trent is a large abstract grouping of Malkin Edge & Co. tiles on the C&A store on Stafford Street, built around 1960.

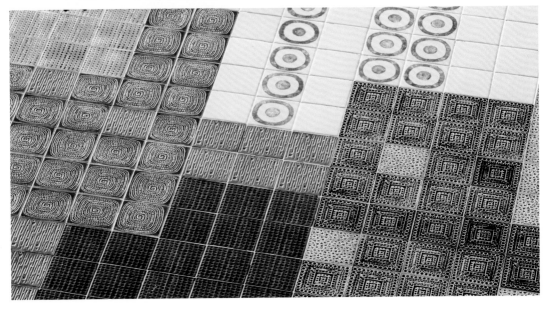

Domestic Tiles of the 1950s

Modernist British tiles of the 1950s were not simply derivative of other graphic, fabric and ceramic design. Technical innovation was important, especially in relation to screen printing, and tile manufacturers had an advantage over other ceramic producers, as screen printing was not suitable for curved surfaces. Tableware decorators had to opt for either hand painting or transfer prints applied to one-dimensional curves until the end of the decade, when the mechanism for placing transfers accurately on surfaces curved in two dimensions became available.

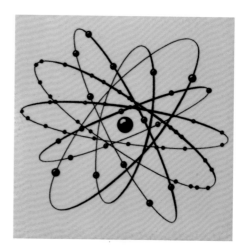

Atomic motifs were popular for some years after the Festival of Britain. This is by Florian Tiles.

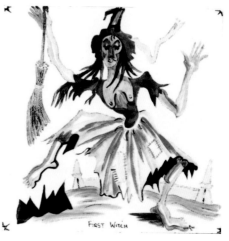

FIRST WITCH

Packard & Ord produced mostly traditional designs, but one painter in the early 1950s added some vigour – in this case, the First Witch from Shakespeare's *Macbeth* on a Carter & Co. blank, dated 1952.

The 1950s saw the closure of many of the sixty larger tile factories in Britain that had been so successful in the Victorian and Edwardian periods. Data from the Glazed and Floor Tile Association suggested that Britain had the second lowest per capita tile usage in Europe. But despite this background, several important smaller producers appeared and there was growth in production from the remaining established industrial manufacturers.

Carter & Co.

Carter & Co. led the domestic tile market during the 1950s, just as they produced most of the tiles used by architects. Their catalogues show over a dozen sets of picture tiles, each set comprising up to six or twelve images. These were suitable for the kitchen, bathroom or fireplace, and could also be set into table tops, where they were usually placed one at a time among plain background tiles. Many of the decorated tiles continued to be hand painted, with designs that dated from before the war, but as time progressed, newer designs and screen printing were more prevalent.

In addition to the picture tiles, patterned tiles could be arranged to make large geometric patterns, either on a large scale, as in contemporary architectural projects, but also in simpler stripes and diamonds.

Above: Although screen printing was usually used to place blocks of colour side by side, Reginald Till explored printing in layers, as shown in one of his designs for Carter & Co.

Left: One of the first screen-printed series of tiles from Carter & Co. in the early 1950s was 'English Countryside', designed by Reginald Till.

Peggy Angus screen-printed design
on a 4-inch Carter tile, dated 1950.
Variations on the central motif
include a Scottie dog and thistle.

Geometric tiles possibly designed
by Alfred B. Read for Carter &
Co., 1955 and 1957.

In the 1950s, fireplaces were
delivered ready tiled from the
builder's merchant in three or four
ready-tiled concrete slabs. This
is an example from a 1958 trade
catalogue, showing screen-printed
tiles by Carter & Co.

Y7136 — 56 in. wide x 37 in. high x 6 in. projection. Dull and Silk Screen
Printed Tiles, Faience Blocks to fire opening, Barless Fire 18 in., black
or cream vitreous enamelled Fret, Brick Back and Raised Easyclean
Hearth. £23/5/6

A group of 4-inch tiles from Carter & Co.; those with the central shamrock motif were designed by Alfred B. Read.

Monochrome tiles by Carter & Co., from the 1950s to the early 1960s. Designers include Alfred B. Read and Gordon Cullen. They are screen printed apart from the web bottom right, which was a hand-painted trial by Phyllis Butler, 1963.

'Sun and Moon' was a popular design by Peggy Angus, first drawn around 1949. It also appeared on wallpaper, where Peggy Angus preferred the use of lighter and darker shades of the same colour to reduce contrast, as shown on the right.

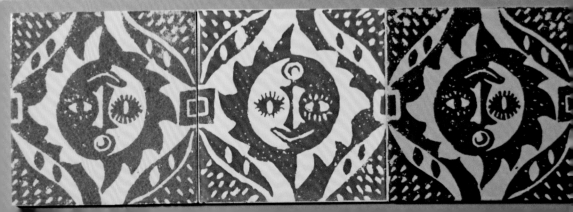

4-inch tiles from Carter & Co., 1957.

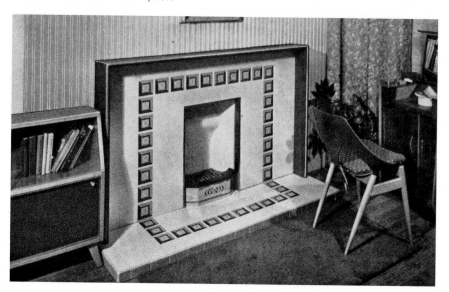

Fireplace with geometric Carter & Co. tiles in a late-1950s living room.

Stoke-on-Trent

Stoke-on-Trent was the engine house of British ceramics, but was perhaps less enthusiastic to embrace the *avant garde*, as historical reference generally sold more ceramics than Modernism. Some Mid-century Modern designs were produced, though they tended to be slightly muted, being better to coordinate with other household furnishings. Manufacturers in Stoke included Richards Tiles Ltd, H & R Johnson, T. & R. Boote Ltd, and Campbell Tiles Ltd. Another notable company was Malkin Edge & Co., who commissioned a range of moulded tiles from a young designer called Kenneth Clark.

A tradesman's sample set in the 'Effects' range from H & R Johnson, on 4.25-inch tiles – it dates from 1958.

Striking design from Richards Tiles Ltd of Stoke-on-Trent, 1955.

Cork-backed tiles used as coasters, printed onto Pilkington's Tile & Pottery Co. blanks, dated 1957.

Richards Tile Co. produced an iconic cat-and-bird moulded tile around 1905 in the Art Nouveau style. One could speculate that this screen-printed version from 1957 may be a homage to the original.

Kenneth Clark and Ann Wynn Reeves

Kenneth Clark (1922–2012) is the premier figure in British Mid-century Modern tiles. He was born in New Zealand and came to Britain after serving in the Royal Navy. In the immediate post-War years, he studied at the Slade School of Art and then at the Central School of Art, founding Kenneth Clark Ceramics with his wife Ann Wynn Reeves in the early 1950s. Kenneth Clark was a master of the technical aspects of ceramic production and, together with Ann's design skills, they were successful for several decades. In the mid-1950s Kenneth Clark made a series of relief tiles with abstract designs, the moulding incorporating craft influences. Glaze colours were stronger than those generally used in the 1950s, in many ways anticipating the 1960s. Malkin Edge & Co. commissioned a series of these with slightly softer colours and with some incorporating printing. This range was most effective on fireplaces and table tops, but was also used in a large tile mural in Stoke on Trent (see page 28).

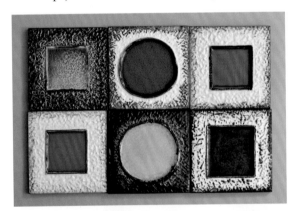

Moulded tiles by Kenneth Clark, made around 1955. A master tile was made from wet clay and a resin mould was then formed to make the production tiles.

A fireplace using relief-moulded tiles by Malkin Edge & Co. These were designed by Kenneth Clark and adapted by Leonard King, and can also be seen on a mural in Stoke-on-Trent (see page 28).

'Turinese' tiles from a tradesman's sample set, these are 4.25 inches square and designed by Kenneth Clark for Malkin Edge & Co. These were made in 1962.

Group of tiles designed by Kenneth Clark and Leonard King for Malkin Edge & Co.; they probably started life on a table top or fireplace in the late 1950s or early 1960s.

Other 1950s Tile Makers

Other major manufacturers included Modernist designs in their new ranges. Pilkington's Tile & Pottery Co., based near Manchester, had been making tiles since the Arts and Crafts era, and produced patterned tiles for architectural and domestic use.

Showing a strong Art Deco influence but demonstrating post-War colours, this galleon was printed by H & G Thynne of Hereford, 1949.

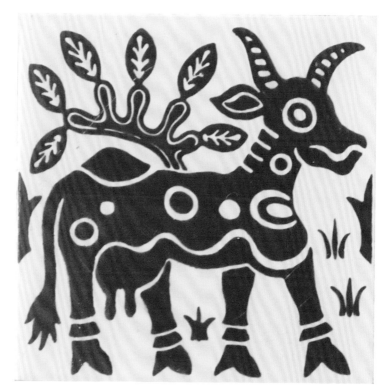

Richards Tile Co. of Stoke on Trent produced some screen-printed animals on to 4-inch tiles soon after austerity was lifted; this example dates from 1953.

Pilkington's Tile & Pottery Co. produced these rather muted designs in 1953.

Many smaller companies produced tiles in the Modernist style during the 1950s and, apart from Carter & Co., it is to these producers that the twenty-first-century collector can look for some striking designs. They include H & G Thynne Ltd, Hereford Tiles Ltd, The Dovecot Studios, Purbeck tiles, Jersey Tiles, Candy & Co., The Dorincourt Potters, and Florian Tiles. The Dovecot Studios deserve special mention because of the designs of Robert Stewart.

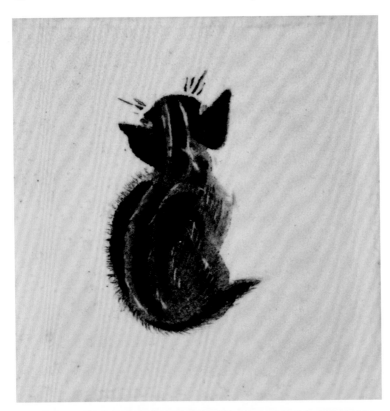

Polly Brace designed a series of kittens for Dunsmore Tiles in the mid-1950s, painted on to 4-inch tiles.

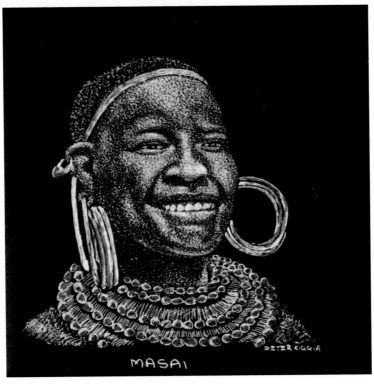

Masai figure drawn by the Kenyan artist Peter Kiggia, printed onto a 1959 Carter & Co. blank.

Attractive design from 1955, painted by Alastair McDuff for Dorincourt Industries; it perhaps shows that this style of decoration is better suited to screen printing than to hand painting.

Robert Stewart

Robert Stewart (1924–95) studied and then taught at the Glasgow School of Art. His designs encompassed textiles, graphics, painting, and ceramic tiles. His fabrics were especially important; at one stage in the 1950s there was an agreement that Liberty of London would commission their designs from Robert Stewart, while their competitor Heal's would use Lucienne Day. Each company would not seek commissions from the other's designer. His quirky drawing style was well suited to tile design and, though they were not produced in large numbers, they are exciting collectors' finds in the twenty-first century. Tiles were screen printed at the Dovecot Studios, Edinburgh, from 1954 onwards. Their primary product was tapestry, but ceramics including tiles, storage jars and mugs provided useful extra income for a decade or so.

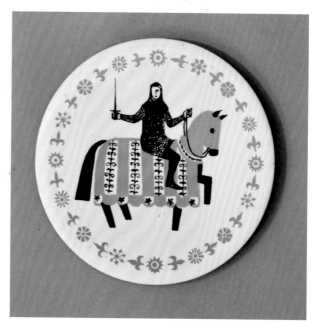

The knight from the 'Canterbury Tales' series by Robert Stewart for Dovecot Studios.

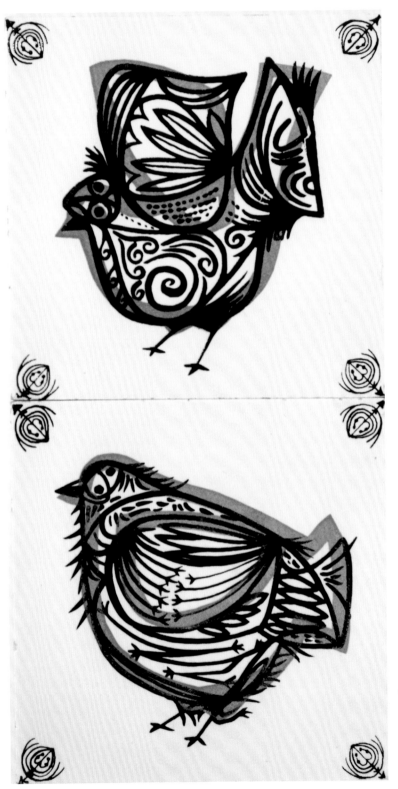

Robert Stewart designed four variations on a bird theme for Dovecot Studios; each of these is screen printed onto a Carter & Co. blank of 1955.

Abstract birds by Robert Stewart, surrounded by a black-and-white chequerboard on a table top; this example was a wedding present in 1963.

Robert Stewart designed tourist souvenir tiles with figures in Scottish dress.

By end of the 1950s, designers such as Peggy Angus and Robert Stewart were key players in the British Modernist movement and bought their experience from media such as fabrics and wallpaper to ceramics. Screen printing, popularized by Reginald Till and Carter & Co., was exploited by larger manufacturers and also allowed smaller companies and new designers to develop, though there was still a demand for good-quality hand painting. By 1960 the demand for decorative tiles in large architectural projects was coming to an end, but the domestic market was strong, with a younger generation keen on Modernism and ready also to get their hands dirty with the new 'Do It Yourself' craze.

Fruit design for Dovecot studios, possibly designed by Robert Stewart, 1950s.

Phyllis Butler for Carter & Co. showed how effective hand painting could be, but production would have been slow for these quality items.

A. Bell & Co. of Northampton were suppliers of fireplaces, tiles and other interior hardware. They used hand painting in the 1950s, in this case with blanks from H. E. Smith of Hanley, Stoke-on-Trent.

Do it Yourself in the 1960s

During the 1960s, fashion, music and lifestyle all underwent revolutions. In the Mid-century Modern home, gone were the soft pastel colours of the 1950s; in were brash synthetic shades of red, orange and purple. Impacting particularly on the domestic tile market was an explosion in 'Do It Yourself'. No longer was the tradesman an automatic requirement for any work in the home, but you could do it exactly as you wanted.

Finding exactly what you wanted was not always easy in the 1960s, as the distribution of tiles was through builders' merchants, who traditionally had sold little direct to the general public. Manufacturers responded to the DIY movement by making tiles thinner, and thus easier to transport and to cut into shape. Rather than using cement or mortar to fix tiles, new user-friendly adhesives were developed. Additionally, the increasing numbers of local craft ceramicists meant that the discerning buyer

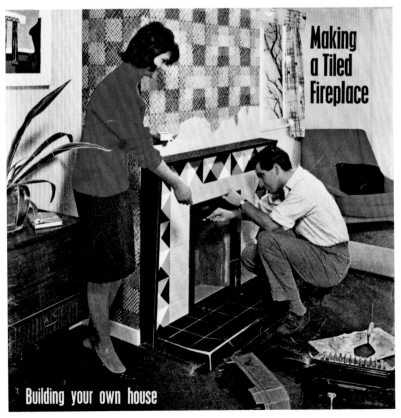

The DIY trend of the 1960s encouraged home tiling projects. The instructions for this fireplace suggest 'slabbing up' the tiles onto concrete blocks and moving the completed fireplace indoors in three or four sections.

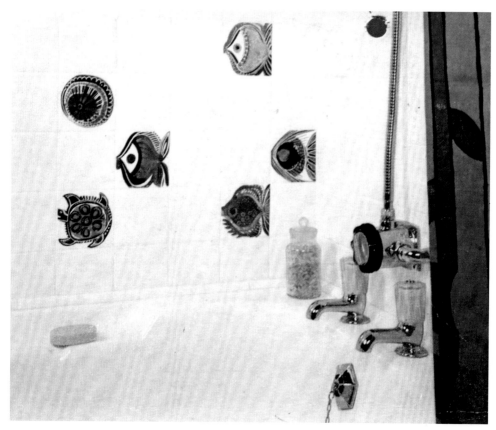

Accent tiles set in a plain white background.

could purchase a few expensive accent tiles and then place them among cheaper plain-coloured tiles. Since many of the smaller producers decorated plain tiles from a major manufacturer, the more expensive fashionable tiles would blend seamlessly into such a scheme.

Kenneth Clark and Ann Wynn Reeves

Of the craft tile makers outside the large industrial outfits, Kenneth Clark and Ann Wynn Reeves were pre-eminent. Particularly significant was the manner in which Ann Wynn Reeves exploited a new method of decoration developed by Kenneth Clark.

A glaze with a high copper content was screen printed to a plain white tile. After firing, the coppery glaze turned matt black and bled slightly into the surrounding white glaze to soften the effect, and blobs of coloured glaze were added. This technique was ideally suited to Ann Wynn Reeves's drawing style and was more effective than simply screen printing a black gloss enamel onto a while glazed tile. A snowflake motif was used extensively, particularly in earlier examples. Other designs incorporated musical instruments, alcoholic drinks, nursery rhymes and other themes for the kitchen and children's rooms.

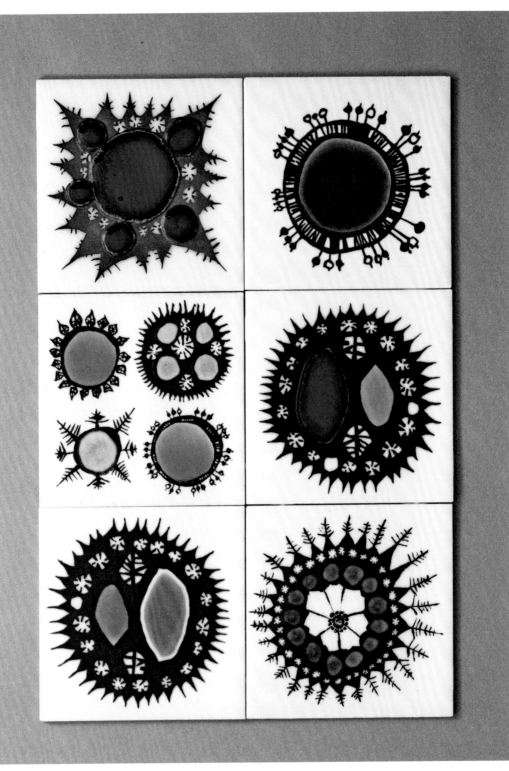

Designs from Ann Wynn Reeves, including Snowflakes, Starflower and Crystal, dating from 1961 to 1977.

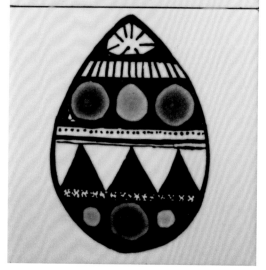

Tiles by Ann Wynn Reeves in a nursery style: top is Paper Hats; centre is Father Christmas; and lower is Painted Egg. Tiles date from 1961 to 1964.

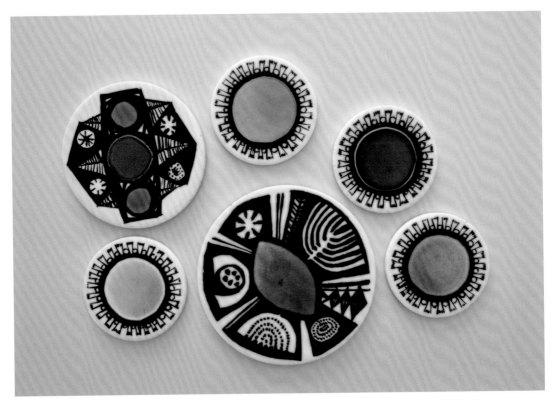

Coasters by Ann Wynn Reeves, 1962 to 1964.

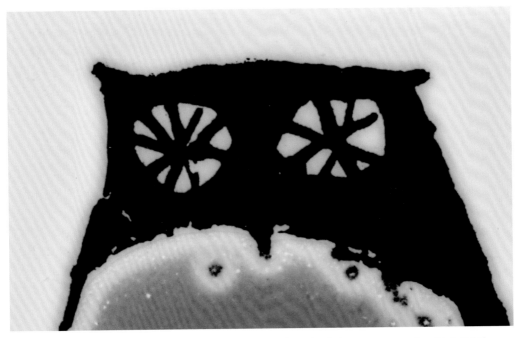

Detail of an Ann Wynn Reeves owl from 1961, showing how the dark-green copper glaze bled slightly into the surrounding white gloss.

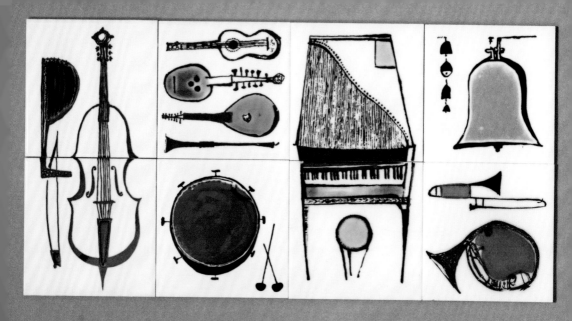

A set of musical instruments designed by Ann Wynn Reeves. Dated between 1959 and 1977.

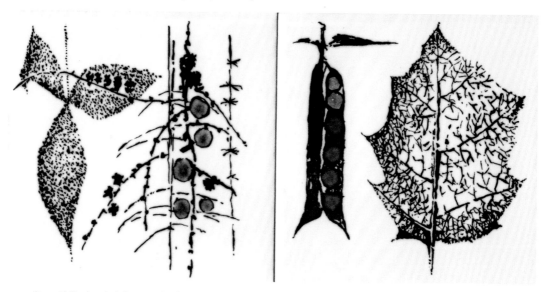

Beautifully detailed drawing by Ann Wynn Reeves: Leaf and Cones is on the left, and Maple is on the right. Both are dated 1961.

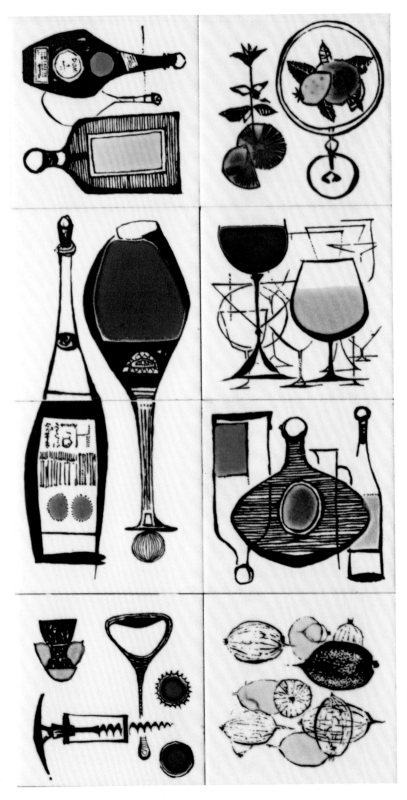

A drink-related series by Ann Wynn Reeves, designed in 1960. These examples were made between 1961 and 1964.

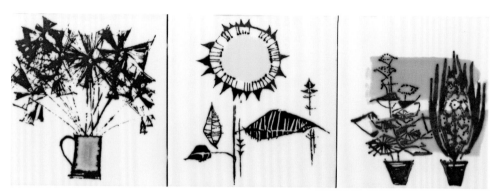

Flower designs by Ann Wynn Reeves, dated 1964 and 1965.

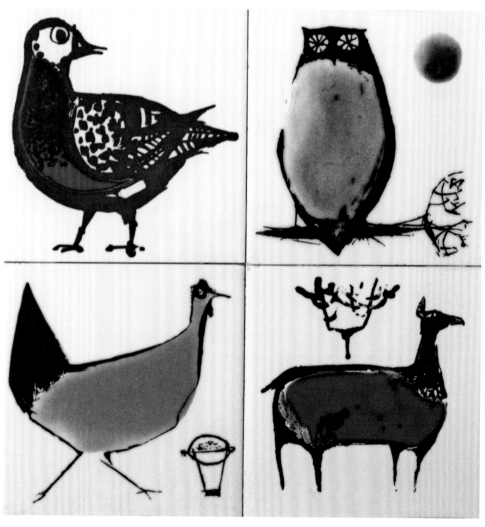

Animals by Ann Wynn Reeves, designed around 1960; these were executed from 1961 to 1977.

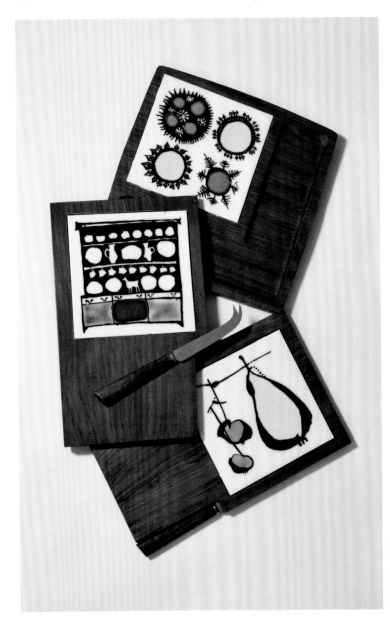

Left: Cheese boards or titbit trays were often made in teak with inset tiles; these were designed by Ann Wynn Reeves.

Below: Nursery rhyme tiles by Ann Wynn Reeves; these examples date from 1961 to 1977.

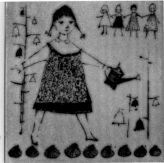

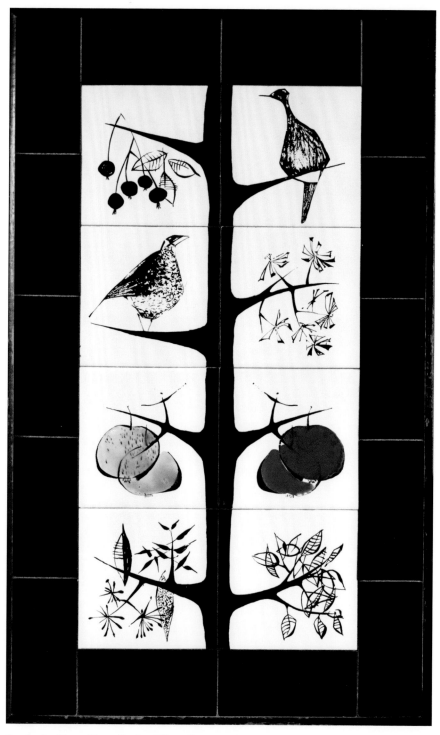

Everlasting Tree table top by Ann Wynn Reeves, early 1960s.

Many of her designs are still in production over fifty years later. They are still made to an excellent standard, though the coloured embellishment is usually of a less strong intensity than in the 1960s. A look at the back of a modern tile will reveal that the body is buff coloured and usually without a manufacturer's mark, as opposed to the earlier tiles made on a white clay body marked H & R Johnson and with a moulded date from the 1960s or 1970s.

Other manufacturers tried to adopt the same technique, but with far less impact. It seems that Ann Wynn Reeves's ability to draw detailed images with many thin pen strokes bought out the best of the technology. Rhys and Jean Powell were arguably the only other tile makers to adapt this technique successfully; examples of their work are shown in the next chapter.

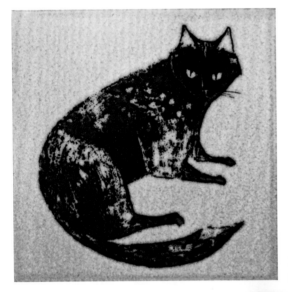

Black cat, designed by Ann Wynn Reeves, on a 1960s H & R Johnson blank.

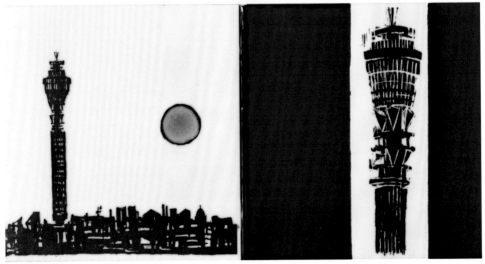

The Post Office Tower in London was completed in 1964. Ann and Kenneth Clark were commissioned to produce two commemorative designs.

The train set designed by Ann Wynne Reeves in 1960 remains in production over fifty years later. Modern tiles are made to a high standard, but the direction of travel of the train has been reserved.

Copper glazed tiles from Ann Wynn Reeves and Kenneth Clark, late 1960s and 1970s.

Other Tile Makers

Peggy Angus was still a consultant for Carter & Co. in the early 1960s, and sent new designs from her Camden Town studio to Poole in the form of lino cuts or drawings, which were converted into screen prints at the factory. Laurence Scarfe was an artist who designed for both Carter & Co. and for Kenneth Clark Ceramics. He studied at the Royal College of Art in the 1930s, and then taught at the Central School of Art and Design from 1945 to 1970; he is better known for being a prolific book and poster designer.

Lawrence Scarfe design for Carter & Co., dated 1964–1972.

Carter & Co. tile designed by Robert Nicholson, made in 1960. A 'barbed wire' design was popular, and would blend in with other interior furnishings, especially as all manufacturers used complementary hues from British Standard colour charts.

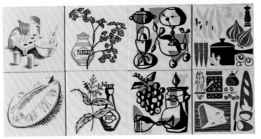

Kitchen tiles from Carter & Co. The left two were designed by Alfred B. Read in the 1920s (these examples are from 1951); next are two from 'Herbs' by Phyllis Butler, also 1950s. It was not until the 1960s that Carter & Co. produced kitchen tiles in a Modernist style – see the four tiles to the right.

Peggy Angus design for Carter & Co., based on Polish paper cut-outs and dated 1962 and 1964.

1963 Carter & Co. tile, set into a stainless steel trivet.

Leaf design on a 4-inch Carter & Co. tile from the mid-1960s, possibly by Ivor Kamlish.

Tiles by Carter & Co. from 1962, with an Ivor Kamlish design. Each is 4 inches square.

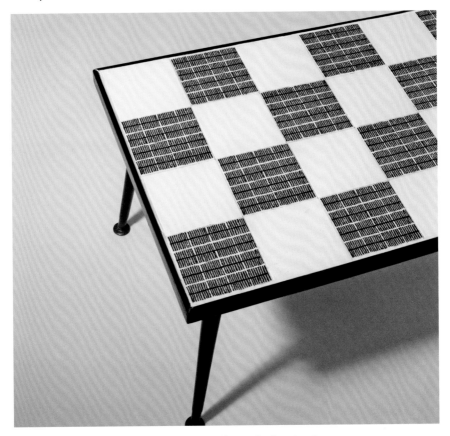

A table with tiles by Ivor Kamlish for Carter & Co.; each tile is 4 inches square.

Alfred B. Read design for Carter & Co., 1963.

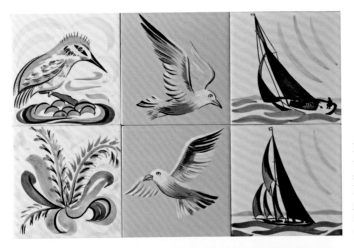

Hand-painted tiles; the left two are from the Lakeland series, designed by Phyllis Butler for Carter & Co. The gulls and yachts were painted in the 1960s on to Carter & Co. blanks.

Moulded tiles by Pilkington's Tile & Pottery Co., 1963. Designed to be used on interior walls.

Peggy Angus continued to design for Carter & Co. in the 1960s; this example was made in 1971.

Moulded tiles from Carter & Co. for interior walls. The right tile was designed by Alfred B. Read, and the others by Ivor Kamlish.

Although painted tile murals became less popular in the 1960s, moulded tiles were extensively used. The 'Turinese' range for Malkin Edge & Co. by Kenneth Clark and Leonard King sold particularly well. Indeed, they were so successful that H & R Johnson were called upon to assist with production, so that many of these tiles were marked as 'Malkin Johnson', and a full takeover by H & R Johnson followed in the mid-1960s.

Contraction of the numbers of manufacturers was not restricted to smaller companies. Carter & Co. itself showed how fragile the ceramic industry can be when it merged with Pilkington's Tile & Pottery Co. in 1964. The company was at first called Pilkington's & Carter, but, although 'Carter Tiles Ltd' was still able to print a marketing flyer in 1968 that did not mention Pilkington's, this was unusual and Carter's individual identity had disappeared by 1970.

In 1965 a review of the decorative tile industry in the UK (*Design* magazine, March 1965) gave figures from the Glazed & Floor Tile Association showing that annual British tile production had increased from 7 to 12.5 million square yards between

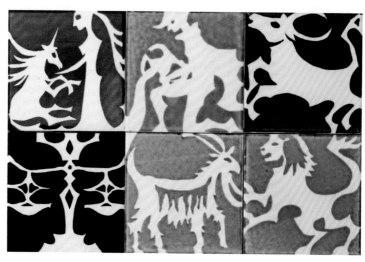

Zodiac tiles screen printed at the Florian Studios, based in Suffolk, in the mid-1960s.

Abstract design, screen printed by Richards Tile Co., 1963.

Art Deco revival by Pilkington's Tile & Pottery Co., 1962.

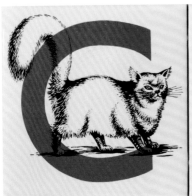

These alphabet tiles from 1966 would appeal to children of all ages.

Dorincourt Industries of Leatherhead, Surrey, employed disabled ex-servicemen. The 'Alpine peasants' series, designed by E. W. Pritchard, was popular. The raffia frames allow them to be used as coasters.

Dorincourt Industries made metalware as well as decorating tiles, so many metal frames are seen with Dorincourt tiles.

1948 and 1963, of which 70 per cent was exported. Almost all this production was of white or plain-coloured tiles. Although 10 per cent had some form of surface pattern or texture, less than 0.5 per cent was the type of decorative tile featured in this book. Fashion was not working in the favour of tiles. The Design Centre in London, essentially the old Council of Industrial Design, was lukewarm about tiles. The Design Centre published a series of short booklets in the mid-1960s aimed squarely at the younger and DIY generation. In the living room, it was recommended that fireplace tiles should be chosen carefully so as not to clash with bolder patterns on curtains and wallpaper. In the kitchen, tiles were 'traditional' and they recommended consideration of newer wall coverings such as plastic or metal.

By 1965, of the fifty to sixty industrial tile makers at the end of the Second World War, most had disappeared and the majority of tiles were made by either Pilkington's & Carter, Richards Tiles, or H & R Johnson. The *Design* magazine reviewer predicted that smaller-scale craft potters would play a central role in the future production of decorative tiles, and so it proved to be.

'Court Card' series, designed by John Mead for Dorincourt Industries and printed on 6 x 3 inch tiles.

African and tribal influences on ceramics in the 1950s and 1960s were led by craft potters such as Michael Cardew and Bernard Leach. This 1960 tile may have been produced by Dorincourt Industries.

T & R Boote blank, backed with cork so it could be used as a coaster and printed with a view of Venice – an aspirational destination for the early-1960s package tourist.

Craft Potters from the 1960s Onwards

The late 1960s marks the end of the Mid-century Modern era. In the 1970s *avant garde* design tended to be either Pop Art or Victorian and Edwardian revival. The larger industrial tile producers followed these trends and, while there is interest in many of their products for a collector, they are not Mid-century Modern. However many craft potters utilised the freedom inherent in a small business to develop their individual styles.

Alan Wallwork's tiles were each unique, but he did divide his circular patterns into styles 'a', 'b' and 'c'; an example of each is shown here, from left to right respectively.

As well as his circular forms, Alan Wallwork used square and anvil-shaped motifs; these are on blank tiles dated 1966.

Alan Wallwork and Clive Simmonds

Alan Wallwork studied pottery at Newlands Park Teachers' Training College in Buckinghamshire and, in the absence of a ceramics teacher, learnt his craft from little more than Bernard Leach's *A Potter's Book*. His next destination was Goldsmiths College in London, where Kenneth Clark was amongst his tutors. He established a gallery in 1957 and, as well as selling ceramics by Lucie Rie, Kenneth Clark and Ann Wynn Reeves, he started to make his own. Experiments with pooled glazes on tiles led him to make a hugely successful range, with characteristic circular or anvil-shaped patterns. The tile would be laid on a turntable, have glazes dripped onto it and then spread around using fingers or simple tools. Eventually this technique proved something that could be imitated by others at less cost, and he concentrated on sculptural stoneware in his later career.

Clive Simmonds (1938–97) graduated from the Bournemouth College of Art and, in 1963, he established the Intaglio Studios in Norfolk. He mostly made tiles with circular designs in a similar style to Alan Wallwork, though with a different technique. He would draw a wax outline on a blank tile, cover it with the background glaze colour and, after firing, add the coloured glazes to the bare areas where the wax had run away before firing again. Clive Simmonds produced some small tiles, down to 2 inches square, as well as the standard 6 inches square or diameter and less commonly figurative designs such as owls. He worked from 1963–1978 in the UK before emigrating to Australia, where he made ceramics for a while before managing a winery.

A group of 2-inch tiles, decorated by Clive Simmonds at his Intaglio Studios in the mid-1960s.

Left: A typical Clive Simmonds tile. He often used circular tiles suitable for use as coasters.

Right: Alan Wallwork and Clive Simmonds inspired other designers in the 1960s and 1970s. Top, a Johnson tile dated 1975; in the middle, Catherine Hicks for Florian Studios, 1970; bottom, a transfer print from 1968.

Screen printed by the Jersey Pottery onto 4.25-inch diameter H & R Johnson blanks, dated 1971.

There were around twenty-five animals in Kenneth Townsend's 'Menagerie' series. The whale, the fox and gorilla (top row) are the least often encountered by modern collectors.

Kenneth Townsend

Kenneth Townsend (1931–99) was an artist and illustrator whose work was widely used by publishers and toymakers, as well as by manufacturers such as Hornsea Pottery and by Chance glass. He also decorated tiles to his own designs from the mid-1960s until about 1980. There are over thirty known designs, with most being animals in the 'Menagerie' series. The humour and distinctive drawing style is in the tradition of

Two of the significant design changes made during production of the 'Menagerie' series.

Kenneth Townsend screen printed the 'Menagerie' tiles, but a few early examples look very much as if they were sprayed through stencils, as seen on the left.

'London Designs' from Kenneth Townsend sold well as souvenirs through the Design Centre, London.

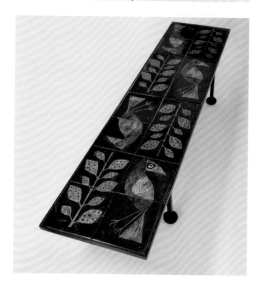

A coffee table decorated with birds and leaves, made by Kenneth Townsend for his own use.

great tile designers of the past such as William De Morgan. Many were sold with cork backs for use as coasters, or with a cardboard backing and metal rings so that they could be hung on a wall. An important outlet was the Design Centre in London, whose sticker remains on many of the tiles today. Townsend used screen printing and, in the Menagerie series, several designs went through different versions, as the screen needed to be replaced or he simply improved the design.

Rhys and Jean Powell

Rhys and Jean Powell met at art school in Liverpool and started making household wares. Their first tile murals attracted attention in the mid-1960s and H & R Johnson, marketing under the Wade name, commissioned bathroom and kitchen tile sets. Their flowing lines, bright colours and gold lustre enhancement caught the mood of the late 1960s perfectly.

They described their products in the 1970s on the packaging thus:

Designed by Jean Powell and hand-made by highly skilled craftsmen, they represent a complete departure from the normal method of tile manufacture but possess the same hard wearing qualities. Each tile is unique in its design. In some tiles molten glass

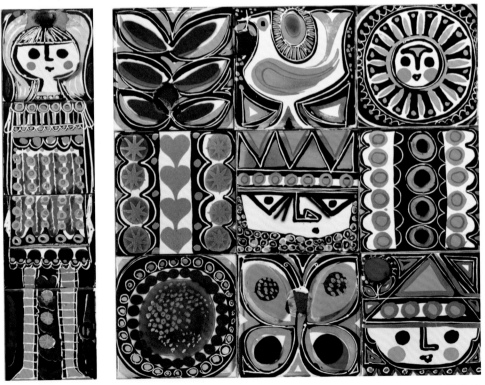

Left: Tall girl by Rhys and Jean Powell, 1960s. The Powell tiles in this book are all on 4.25-inch H & R Johnson blanks.

Right: Part of the 'Royalty' series by Rhys and Jean Powell, late 1960s.

Rhys and Jean Powell also worked for H & R Johnson (the tiles marketed as 'Wade'). Pictured are the Bathroom and Kitchen series in their original display packing.

Panels of 4.25-inch tiles, designed by Jean Powell and made at Powell International Tiles Ltd, Denbigh.

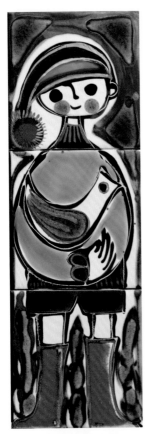

Left: Boy holding a bird – a typical design from Jean Powell in the late 1960s. Versions of this were produced through the 1970s.

Below: In the early 1970s Jean Powell experimented with ceramic flowers applied to the front of tiles, marketed as 'Denbigh Jewels'. Some used local Welsh red clay (right).

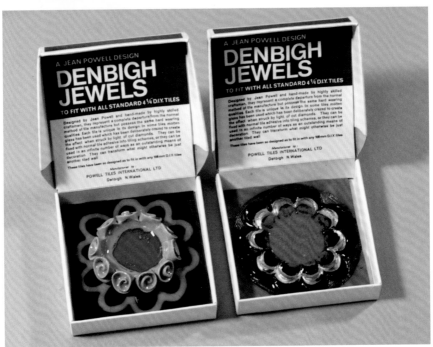

has been used which has been deliberately crazed to create the effect when struck by light of cut diamonds. They can be fixed with normal tile adhesive into tiling schemes, or they can be used in an infinite numbers of ways as an outstanding means of decoration. They can transform what might otherwise be just another tiled wall. *These tiles have been designed as to fit with any 108mm D.I.Y. tiles. Warning. The gold used is real gold and can, if scoured, be worn away.*

Rhys and Jean Powell were important tile designers and makers from the 1960s, not just because of the quality of their output but because their company has grown to produce important tile murals for an international market right through to the twenty-first century.

Kenneth and Ann Clark

The duo of Kenneth Clark and Ann Wynn Reeves continued to make tiles in tune with the times. As the copper-lined glazed outlines became less fashionable, they continued to make screen-printed tiles with ever more delicate designs and softer colours. Bubbling red and orange 'reactive' glazes were evocative of West German 'Fat Lava' ceramics. A whole range of other techniques were explored, some hand painted, others using layers of glaze that were scratched back in scraffito style to reveal the design before firing.

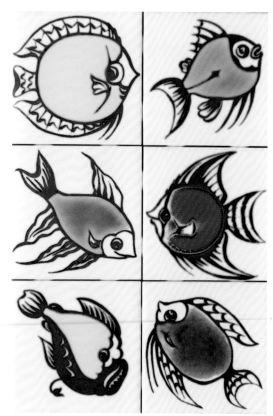

Several manufacturers tried to use the dark matt copper glaze and coloured highlight combination championed by Kenneth Clark and Ann Wynn Reeves. However, the derivatives could not rival the superior combination of drawing and firing of the originals. A set of fish from Marlborough Tiles (previously Packard & Ord), early 1970s.

Kitchen tile by T & R Boote Ltd, 1968. This copies the Kenneth Clark and Ann Wynn Reeves style, but uses a simple green background instead of the more complex copper formula.

West German ceramics of the 1970s famously used red and orange glazes that bubbled and expanded during firing. Here is a 1972 Kenneth Clark tile using a similar 'reactive' glaze.

Carter & Co. tile from 1971, decorated in the style of 'Delphis' from Poole Pottery. Despite the close links between the two companies, it is rare to see Delphis tiles.

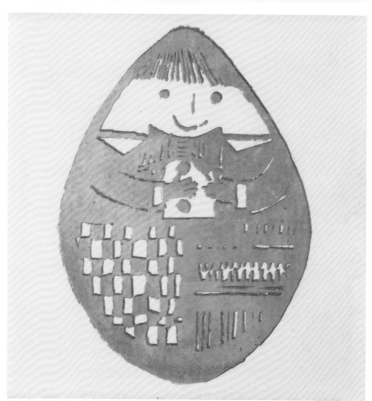

'Humpty Dumpty' by Ann Wynn Reeves, in gold lustre on a blank and dated 1969.

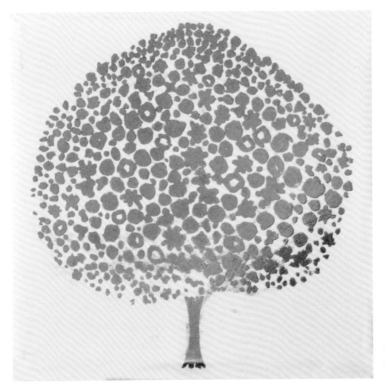

Gold lustre tree by Ann and Kenneth Clark on a blank dated 1970.

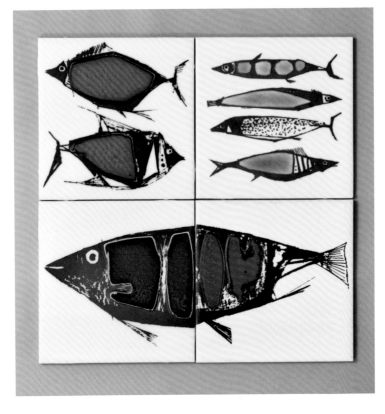

Skeletal, prehistoric fish also featured in Ann Clark's repertoire in the later 1960s and 1970s.

'Autumn', one of Ann Clark's Four Seasons series from the late 1970s, on an 8-inch tile.

Development by Kenneth Clark of the copper-based glaze produced some striking effects when the glaze bled into surrounding colours. This was an Ann Clark design on an H & R Johnson blank, dated 1980.

Hand-painted flower by Ann Clark on a blank dated 1988.

Ann and Kenneth Clark also used stencils and glaze spraying; these tiles both dated 1988.

By the 1970s, Mid-century Modern tile design had either disappeared or evolved into craft-based manufacture. Although mass-produced British decorative tiles were becoming something of the past, the future was equally rich, and worthy of collecting and studying in its own right. British tile design had emerged from the Second World War and austerity to project its own unique style, aided in no small part by the cohort of enormously talented Modernist designers who had studied at the Royal School of Art in the early 1920s. As the craft era developed in the later twentieth century, talent was drawn from a wider background, and new products were born from endless experimentation with clay and glazes.

Thistle and crown design from Dovecot Studios, likely to have been designed by Robert Stewart. It was made around 1970 and sold through the Design Centre, London.

Cheaper travel and television expanded horizons and aspirations in the 1960s. This Mediterranean scene and Far East dancing were printed onto 4.25-inch Carter & Co. blanks.

Screen print by Carter from 1971.

Is this a clown's face? Carter & Co. blank, dated 1969.

Moulded tiles were popular for many years, especially in kitchens. A 1977 gold lustre from H & R Johnson Ltd.

Kitchen tiles by
Richards Tile Co., 1968.

'Suffolk Hedgerows'
was a series designed by
Ann Wallace for Florian
Studios in the late 1960s.

Abstract panel, late 1960s, by John Reilly, who worked on the Isle of Wight. It was mounted by the artist on to white painted chipboard.

Edward Bawden returned to tile design forty years after he first worked for Carter & Co. with murals for station seating on the London Underground Victoria Line, which opened in the late 1960s.

Tile Collecting

The tile is to ceramics what the 7-inch vinyl single is to the music world; small, portable, collectable, and often a masterpiece in its own right. Tiles of all types and periods are avidly collected. There are plenty to go around and many wonderful Mid-century Modern tiles can be purchased for only a few pounds, though an exceptional panel or coffee table may fetch some hundreds of pounds.

How to Identify and to Buy

Identification of tiles depends not only on the front of the tile; always check the back. Most of the manufacturers mentioned in this book marked their tiles.

'Made in England' should be present, together with the name of the maker, and there is also usually the year of manufacture. Pilkington's used a number code for the date, readily deciphered using the internet or a reference book. Note, however, that many individuals or companies simply decorated blank tiles from Carter & Co. or H & R Johnson. While some added their own names with a rubber stamp, this was not always the case. This book, internet searches and larger reference books will hopefully allow most tiles to be identified, but there will be many undocumented designs out there; part of collecting is to have fun chasing that unusual attribution. The Tile & Architectural Ceramics Society can also offer help with identifying unusual tiles.

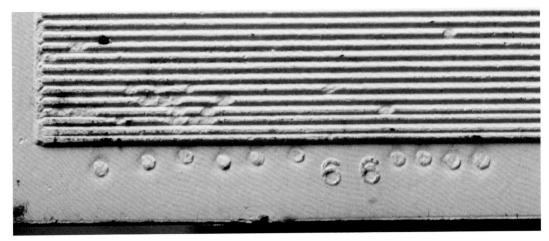

A Carter & Co. tile shows the year and month (the number of dots) in which the blank tile was pressed – in this case, October 1966.

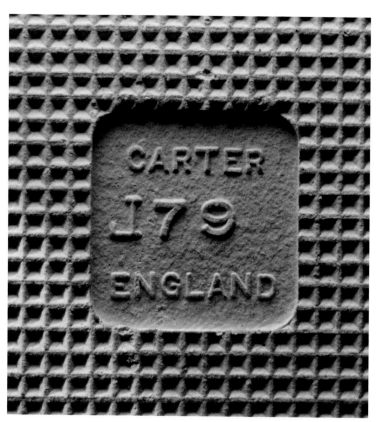

Tiles for exterior use made by Carter & Co. have a central number, which is not the date but a mould number. This was made in the 1950s or 1960s.

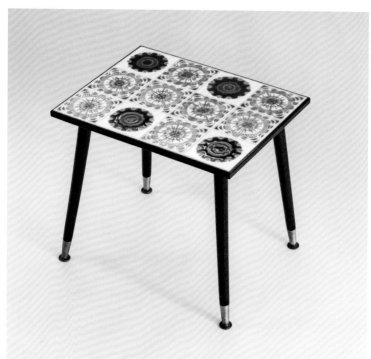

Wooden tables with detachable legs were made in a variety of sizes in the 1960s and could be tiled by a retailer or amateur. This was made for 4.25-inch tiles, in this case supplied by Candy Tiles Ltd. Identification of the maker of tiles on tables can be difficult, as the rear of the tile cannot be inspected. For example, these tiles were at one time incorrectly attributed to Alan Wallwork.

Tiles tended to get thinner over time; this shows a typical 1960s tile on top of another from the 1950s.

H & R Johnson tile with a sticker for Kenneth Clark Tiles of Lewes, Sussex. It is signed by Ann Clark, and bears a rubber stamp showing that it was designed by her before she was married, when she was Ann Wynn Reeves. Many Ann Wynn Reeves designs are still in production over fifty years later on smaller 150-mm tiles with quite different backs; part of such a tile is on the left.

The collector may find
hand-painted trial
designs; these are by
Phyllis Butler, who
worked at Carter & Co.
in the early 1960s.

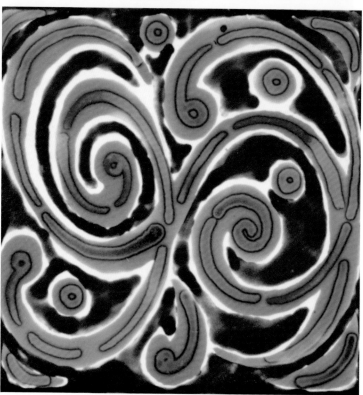

A colourful
hand-painted trial from
Phyllis Butler, 1967.

Glaze trials can be interesting finds; these are from Carter & Co. and date from the late 1950s.

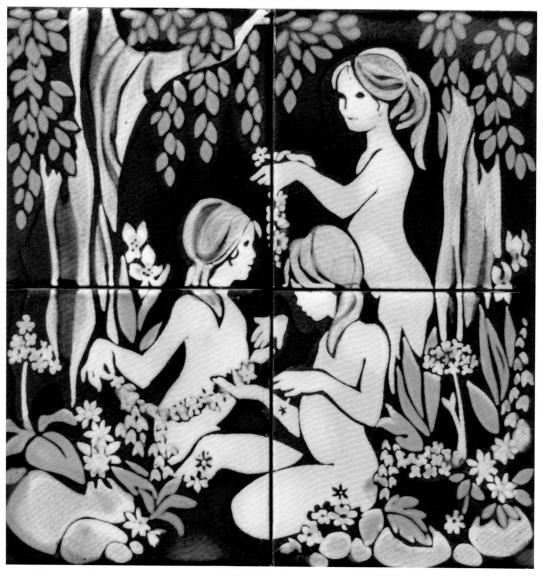

Pilkington's Tile & Pottery Co. had a production facility in South Africa, using the mark 'Pilkington SA'. This group of maidens was decorated at the Liebermann Pottery in Johannesburg.

This book looks at British tiles, but there were also many important manufacturers from around the world, especially in Scandinavia, West Germany and the USA. So a collection could be established by decorative theme rather than simply country of origin.

Internet auction sites are a mainstay of the market, though it should be noted that few sellers will tag their description specifically as Mid-century Modern so search by designer and manufacturer or by 1950s/1960s. Car boot sales, antique auctions and careful perusal of small ads will lead to other good buys.

Coasters made in Japan in the 1950s or 1960s for sale in the USA.

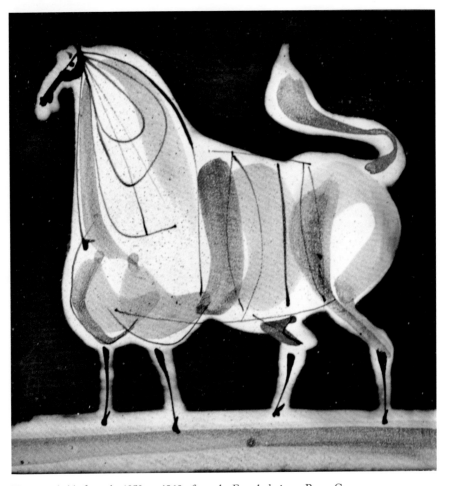

Horse, probably from the 1950s or 1960s, from the French designer Roger Capron.

Wall plaque, 40 x 25 cm, by Helmut Shaffenacker, active in Ulm from the 1950s to 1990s. Large quantities of Mid-century Modern ceramics emanated from West Germany.

Cleaning

The front of a tile can safely by cleaned with warm water. If the surface is bright gloss without marked crazing, a small amount of proprietary window cleaner should be safe (ceramic glaze is, after all, a glassy surface). Careful use of solvents may remove stubborn marks; for example, methylated spirits will remove dried clear adhesive tape. However, be aware that the body of a tile is absorbent; care should be taken regarding immersing a tile in water. If this is done, several changes of clean water need to be used to remove any detergent or dissolved substance. Ideally deionised water should be used, as minerals in tap water can permeate the tile body under the glaze.

If there is staining under the glaze, this is often impossible to remove. Soaking in a detergent made for woollen fabrics may work and, in extreme cases, a poultice with hydrogen peroxide (denture-cleaning tablets are one source) can be applied to the front of the tile. However such approaches risk damage to the tile, and should only be used with caution.

Traces of cement, adhesive or grout can sometimes be scraped off with a fingernail, but be very careful of using greater force, as tiles got thinner through the 1950s and 1960s, meaning they break more easily.

Magazine shelf, just the right size for displaying tiles; in this case it is from the 'Countryside' series, designed by Reginald Till for Carter & Co. in 1951.

How to Display

Sticking your tiles on to a wall with proprietary adhesive is not recommended if you want to get them off again in one piece! However, there are tricks such as putting two layers of thick wallpaper on the wall first. Most tile collectors, though, will display their tiles on table tops, or perhaps will make up a wooden rack. Depending on the environment, tiles may be held in place by gravity alone or using an adhesive that is easily dissolved. Details of how you can display your tiles can be found on the internet, especially the Tile & Architectural Ceramics Society website.

Tiles can be hung on the wall, using an adhesive hook or enclosed within a frame. The rebate of a frame will cover the edges of a tile – useful if there is minor chipping, but annoying if part of the design is obscured. An adhesive can be used to stick the tile on to a backing; this would ideally be a conservation-type adhesive that can be dissolved if you wish to detach the tile in the future.

Storing tiles

Most tiles are pretty rugged, although prone to scratching or chipping on the corners. Robust wooden or plastic boxes suffice for storage. Tiles can be placed with a cardboard spacer between each one or, if spacers are not used, turn alternate tiles round so that they face back to back, front to front, back to back. Don't try and store your tiles in large boxes, as they get very heavy; twenty tiles per box is quite comfortable. If you store any boxes of tiles on shelving or in your attic, think carefully about the weight distribution and safety.

Resources

Places to Visit

Details of locations where tiles may be seen *in situ* are given in the *Tile Gazetteer* and TACS website (details below).

Museums tend to feature tiles older than the Mid-century Modern period, but of note are:

The Potteries Museum and Art Gallery, Hanley, Stoke on Trent, ST1 4HS
The Jackfield Tile Museum, Jackfield, Telford, TF8 7AW
Victoria and Albert Museum, Cromwell Road, South Kensington, London SW7 2RL

Books

Arber, Kate, *Patterns for Post-War Britain: The Tile Designs of Peggy Angus* (Barnet: Middlesex University Press, 2002).
Arthur, Liz, *Robert Stewart Design 1946–95* (London: A. & C. Black, 2003)
Blanchett, Chris, *20th Century Decorative British Tiles* (Atglen PA: Schiffer, 2006).
Bradbury, Dominic, *Mid-century Modern Complete* (Thames & Hudson: London, 2014).
Clark, Kenneth OBE, *The Tile* (Ramsbury: Crowood Press, 2002).
Corbett, Angela and Corbett, Barry, *Pilkington's Tiles* (Great Britain: Pilkington's Lancastrian Pottery Society, 2014).
Farmer, Will, *Poole Pottery* (Princes Risborough: Shire, 2011).
Hayward, Leslie, *Poole Pottery* (Shepton Beauchamp: Richard Dennis, 1998).
van Lemmen, Hand and Blanchett, Chris, *20th Century Tiles* (Princes Risborough: Shire, 1999).
Pearson, Lynn, *Public Art Since 1950* (Princes Risborough: Shire, 2006).
Pearson, Lynn, *Tile Gazetteer* (Shepton Beauchamp: Richard Dennis, 2005).
Russell, James, *Peggy Angus* (Eastbourne: Antique Collectors Club, 2014).
Tile and Architectural Ceramics Society, *Fired Earth – 1,000 years of Tiles in Europe* (Shepton Beauchamp: Richard Dennis, 1991).

Websites

The Humourous World of Kenneth Townsend, www.kenneth-townsend.co.uk
The National Tile Database, www.tessellations.org.uk
Robert Opie (modern Ann Wynn Reeves tiles) http://www.robertopiecollection.com
Craig Bragdy Design (formerly Powell Tiles international) www.cbdpools.com
Marlborough Tiles www.marlboroughtiles.com
Johnson Tiles www.johnson-tiles.com

Societies

Tile and Architectural Ceramics Society, www.tilesoc.org.uk
Twentieth Century Society, www.c20society.org.uk

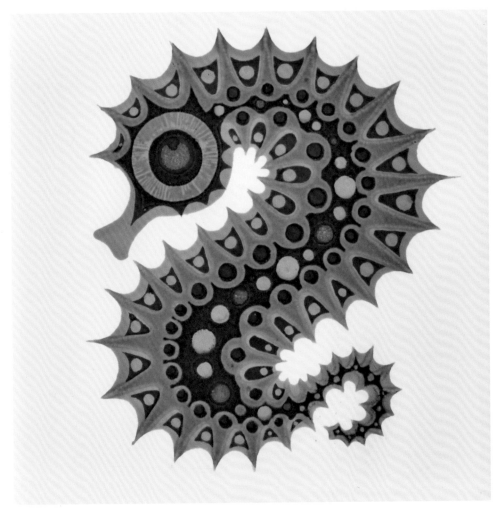

Seahorse from the Kenneth Townsend 'Menagerie' series.